HIYAAA GUYS!!

THANK YOU SO MUCH
FOR BUYING THIS
I HOPE YOU WILL
ENJOY THIS !! ♡♡

LOVE YA!
@RETNOLARAS

GET READY FOR THE

QUIZ

IF YOU REALLY VIP
YOU KNOW THE
ANSWERS FOR THIS

"DON'T BELIEVE IN SUCCESS. RATHER THAN THAT, BELIEVE IN THE AMOUNT OF YOUR ___ AND ___." - SEUNGRI

A. FISH AND CHIPS

B. EFFORT AND PASSION

C. TOM AND JERRY

"AN OPEN ____ IS THE SECRET OF MAKING FRIENDS"
— SEUNGRI

A. FLY
B. SKY
C. MIND

"MY GOAL IS TO BECOME A SINGER WHO DELIVERS _____ TO PEOPLE." — DAESUNG

A. HAPPINESS
B. SAPPINESS
C. LONELINESS

"I HAVE A GOOD PRONUNCIATION NO MATTER WHAT LANGUAGE I SPEAK. MAYBE IT'S BECAUSE MY SPECIALITIES ARE _____ AND IMITATING OTHERS"

— GDRAGON

A. RAPPING
B. WRAPPING
C. FAPING

"THE JAPANESE STAR I WANT TO WORK WITH? _____"
— T.O.P

A. TAKUYA KIMURA
B. YO SHINOYA
C. PIKACHU

"DOPE VIDEO, _____!"
— TAEYANG

A. CONGRATS
B. RUGRATS
C. NOUGATS

"PEOPLE EXPRESS THEIR FEELINGS THROUGH CRYING OR ANGER. WE, BIGBANG, EXPRESS IT THROUGH _____." — DAESUNG

A. TEARS
B. THE NIGHT
C. MUSIC

"I REALY LIKE MY EYES, NOSE, LIPS. I ESPECIALLY LIKE MY NOSE. I REALLY LIKE MY LIPS TOO. I THINK MY LIPS ARE ___." —TAEYANG

A. FOXY
B. SEXY
C. PETTY

"BIGBANG IS JUST LIKE A _____.
SO WE AIM THE SAME THING, NO
MATTER WHERE WE AT." —T.O.P

A. FAMILY
B. FREE WILLY
C. CAVITY

"I THINK A BEAUTIFUL PERSON IS ONE WITH BEAUTIFUL _____."
— GDRAGON

A. NIGHT
B. SIGHT
C. HEART

ANSWERS:

1. B
2. C
3. A
4. A
5. C

6. A
7. C
8. B
9. A
10. C

VIP BE LIKE:
 "ONLY DEEP MEANINGFUL LYRICS GET TO ME"

BIGBANG BE LIKE:
 "BOOM SHAKALAKA"

 "BANG BANG BANG"

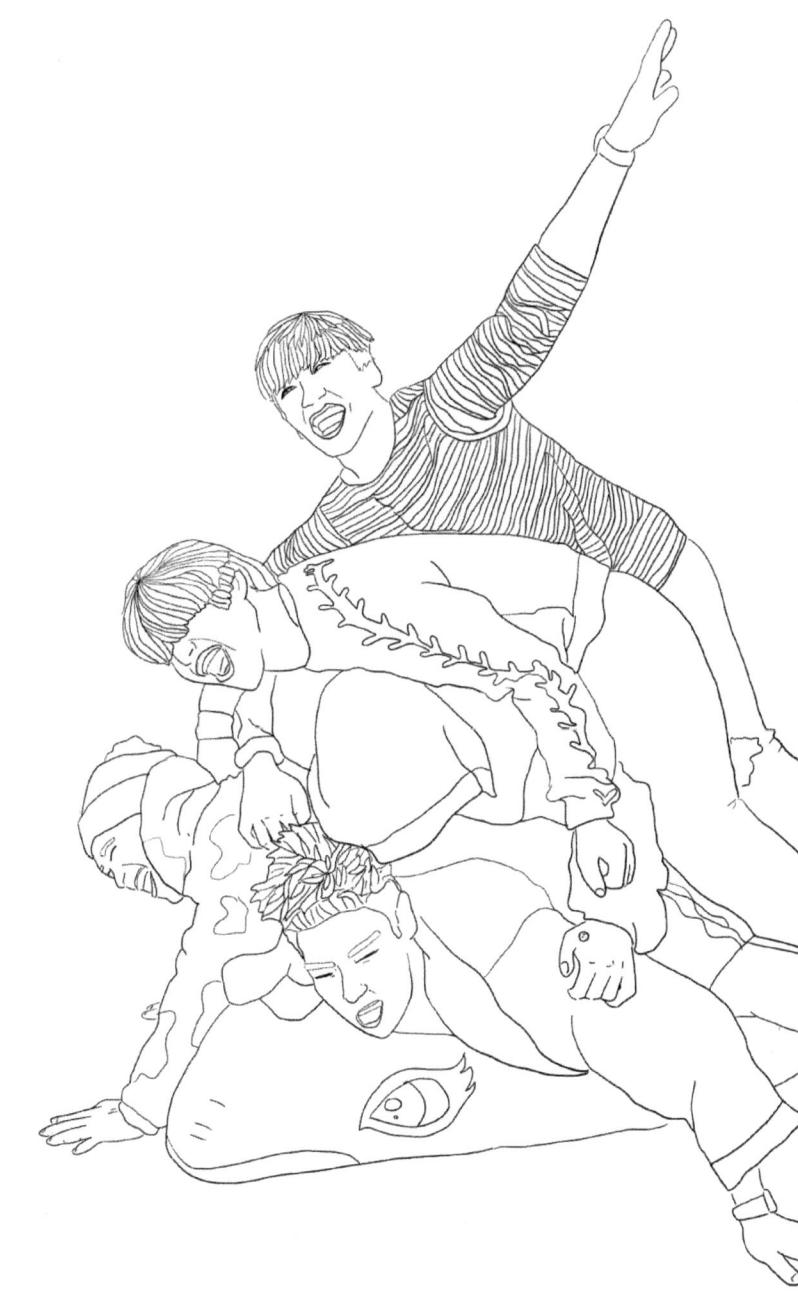

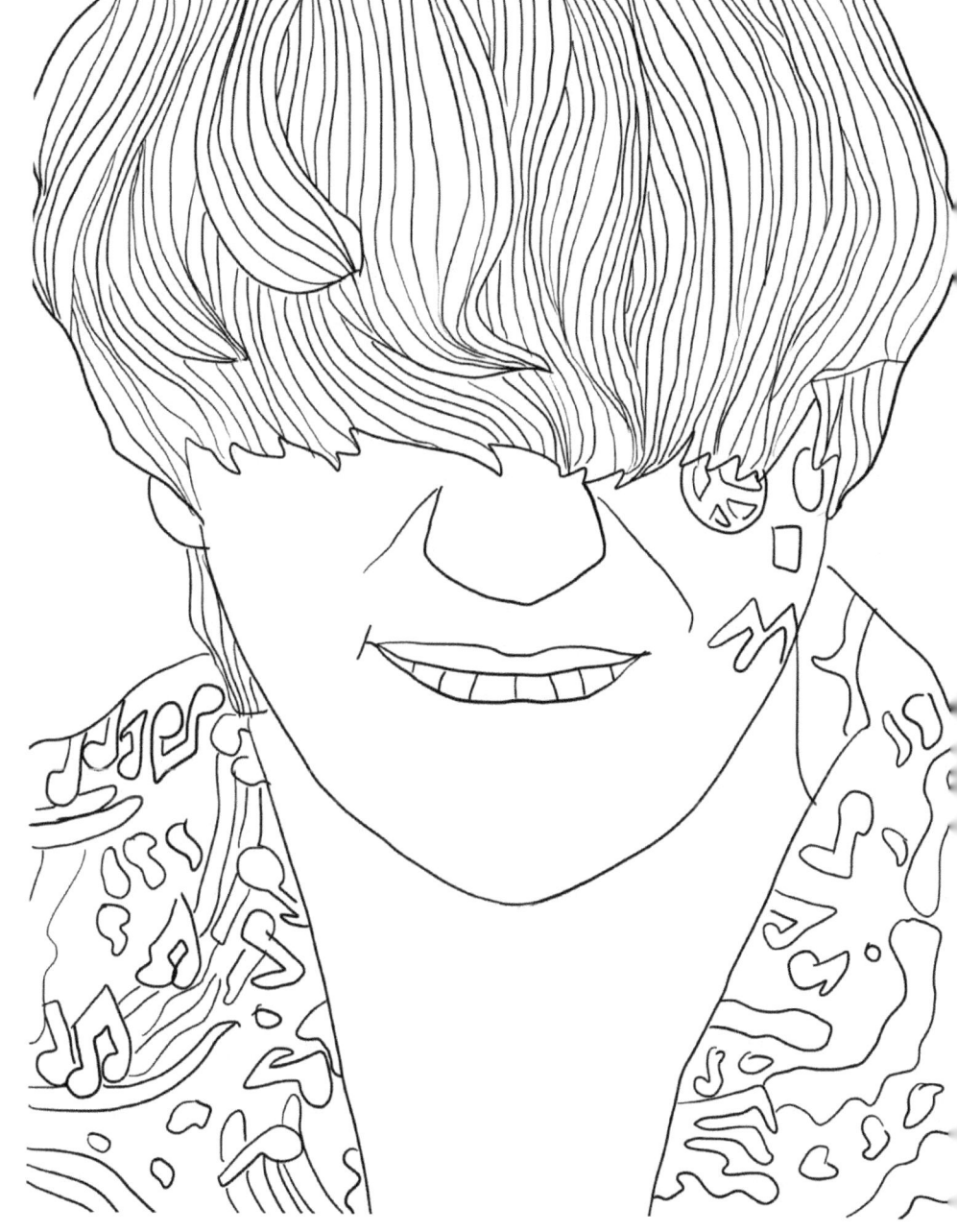

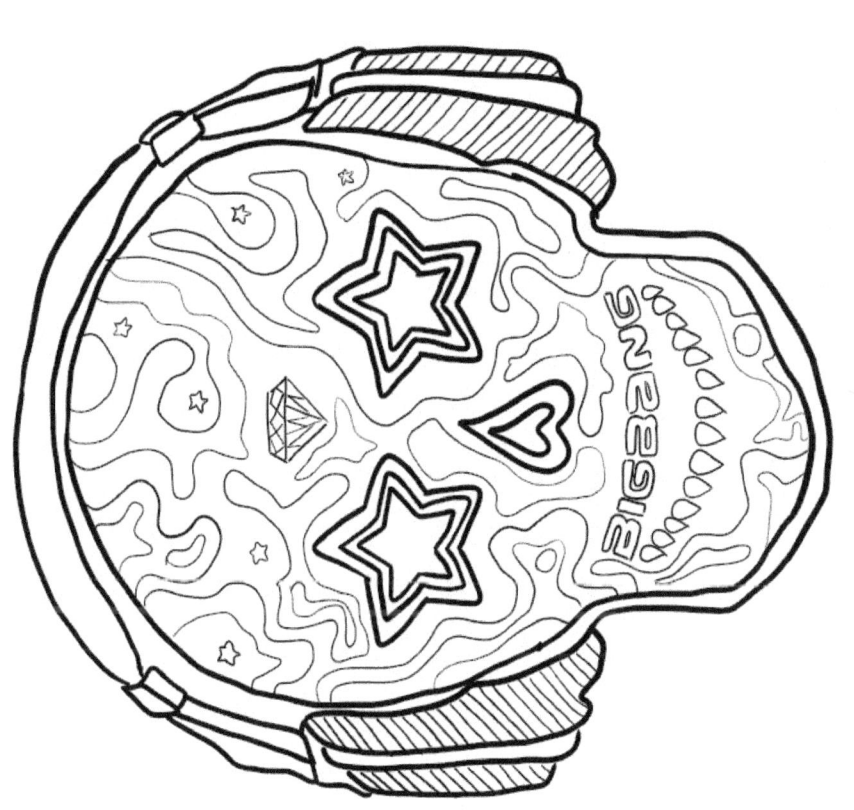

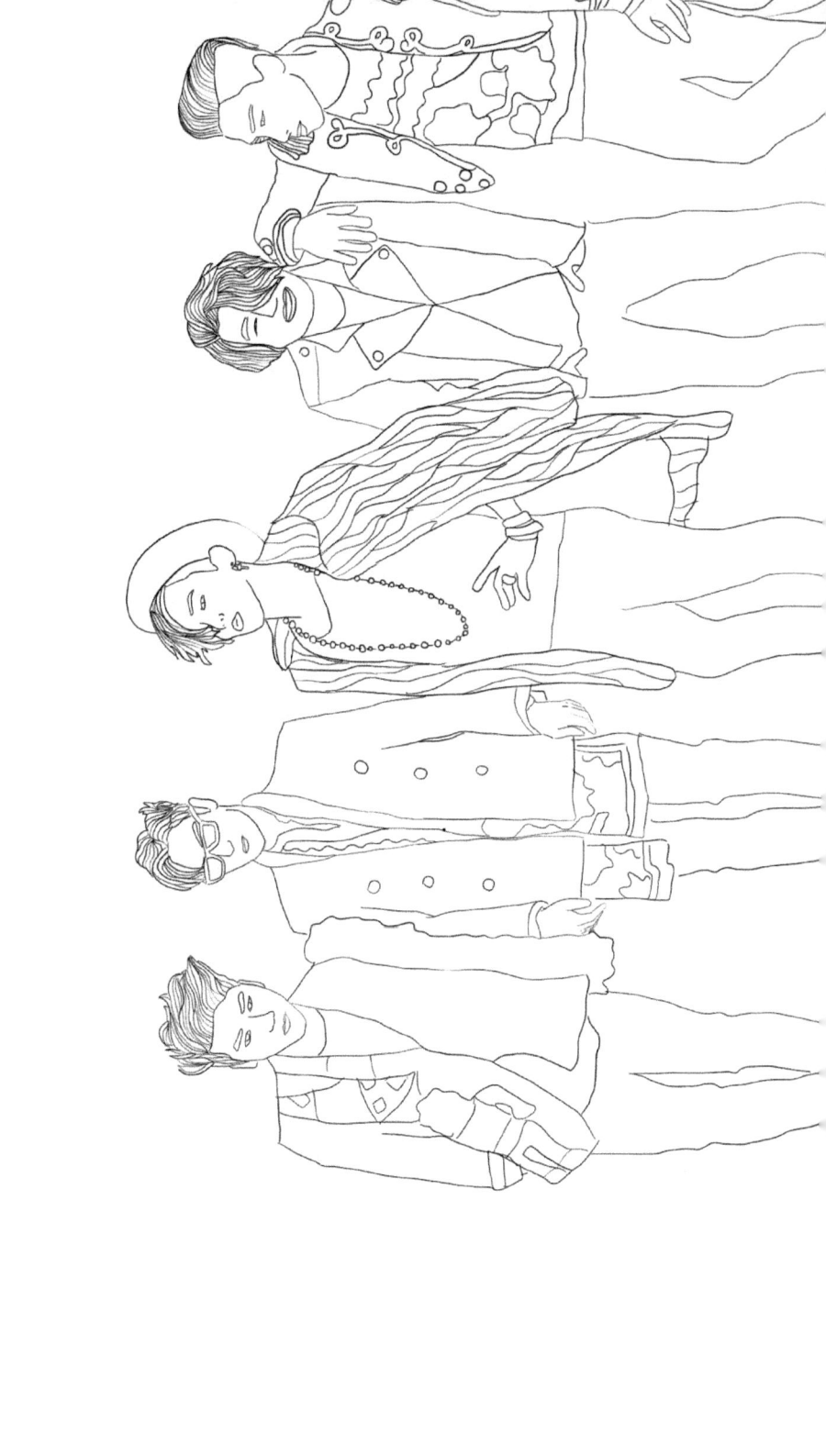

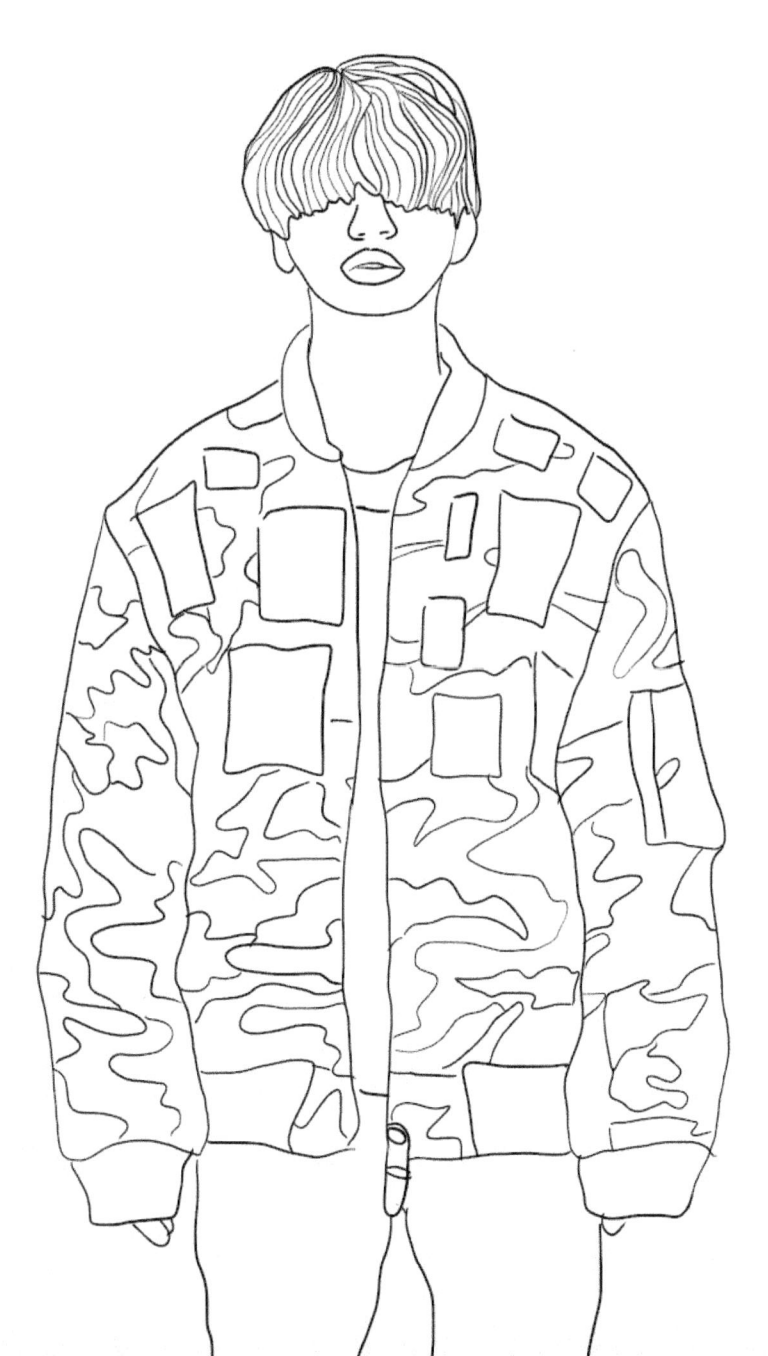

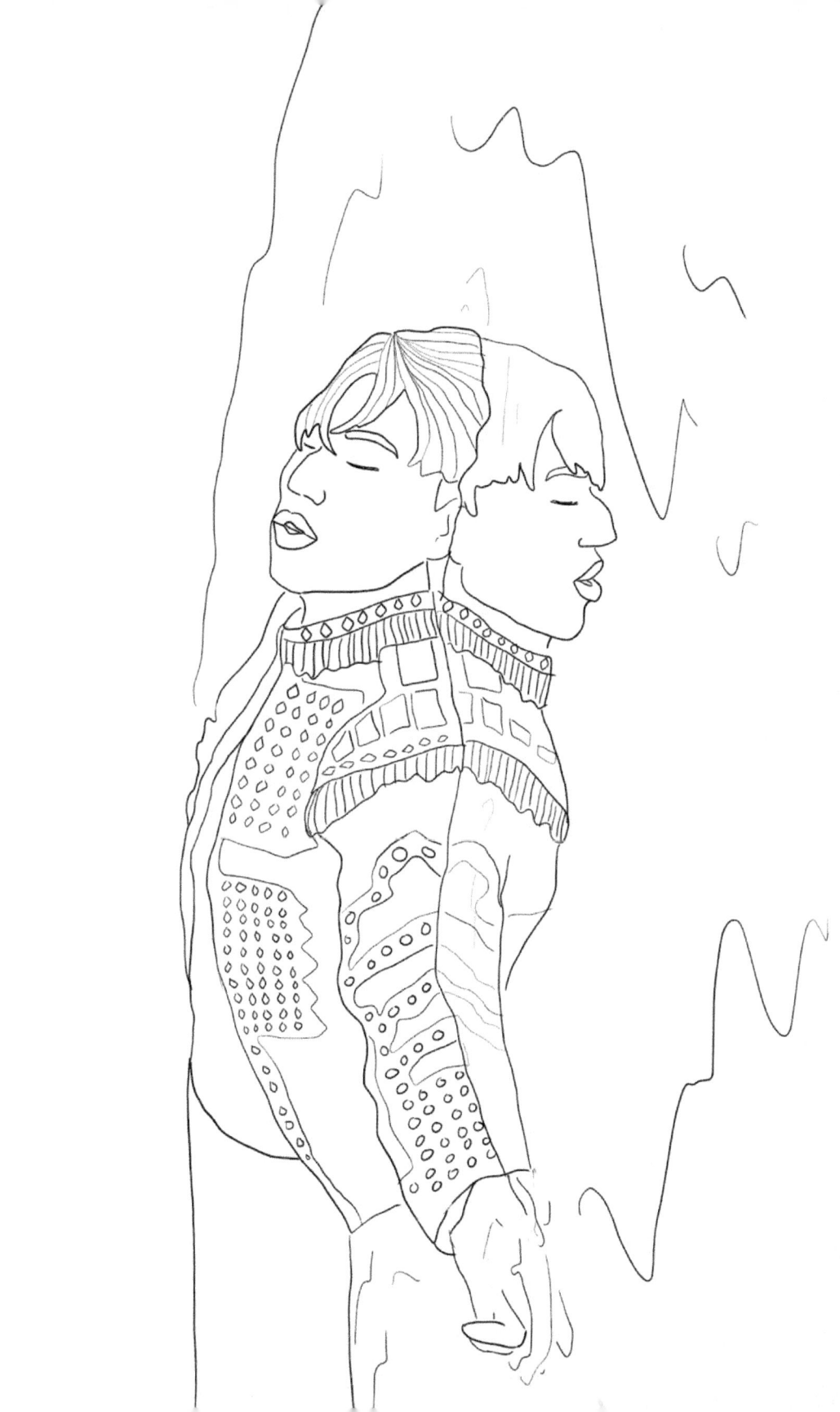

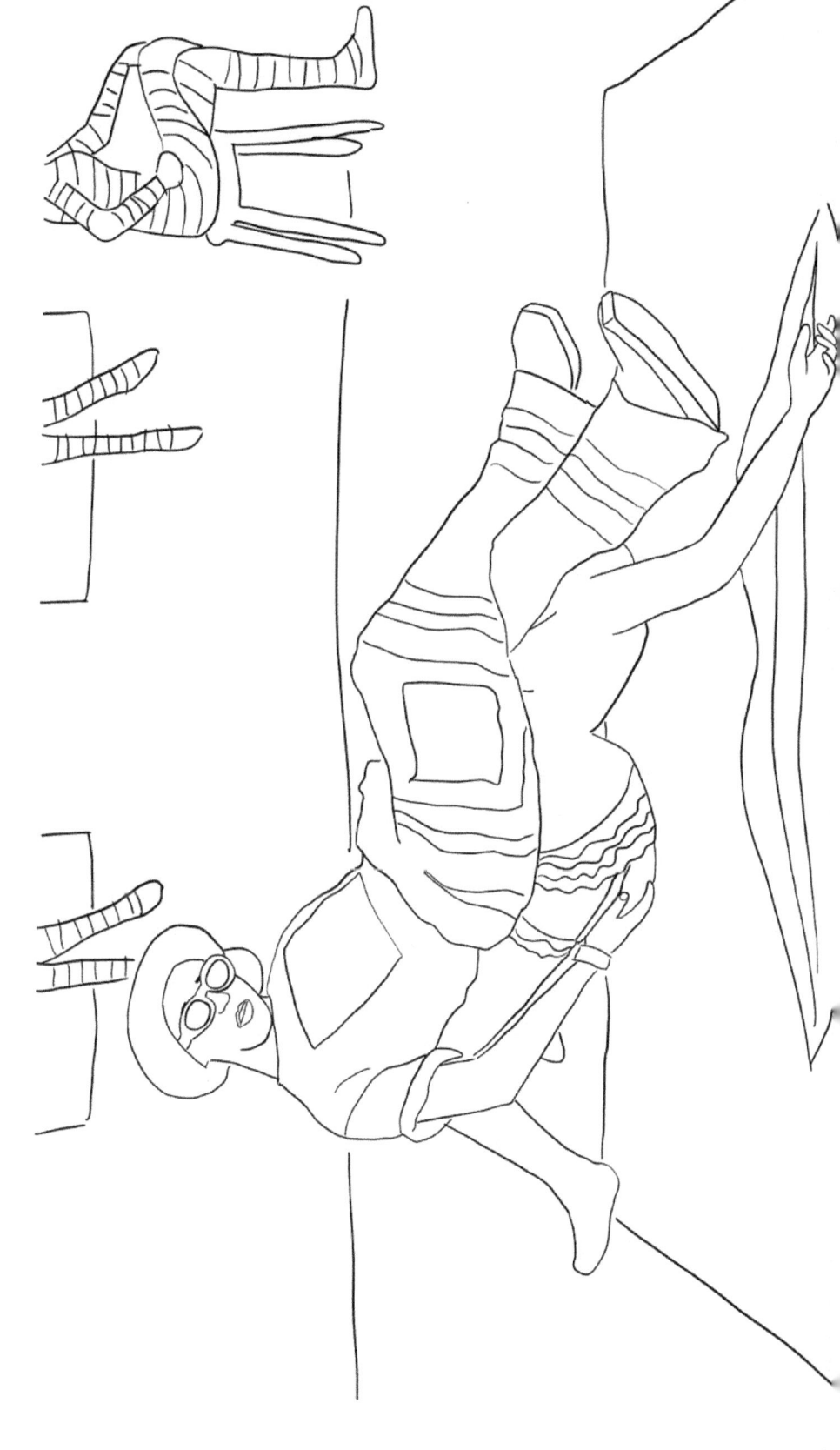

www.ingramcontent.com/pod-product-compliance
Lightning Source LLC
Chambersburg PA
CBHW061445180526
45170CB00004B/1562